IMAGES
of America

SAN BRUNO

This is a 1947 map of San Bruno, California.

2

IMAGES
of America

SAN BRUNO

Darold Fredricks

ARCADIA

Published by Arcadia Publishing,
an imprint of Tempus Publishing, Inc.
Charleston SC, Chicago, Portsmouth NH,
San Francisco

Printed in Great Britain.

Library of Congress Catalog Card Number: 2003110805

For all general information contact Arcadia Publishing at:
Telephone 843-853-2070
Fax 843-853-0044
E-Mail sales@arcadiapublishing.com
For customer service and orders:
Toll-Free 1-888-313-2665

Visit us on the internet at http://www.arcadiapublishing.com

The El Camino Real at the intersection of San Mateo Avenue attracted roadhouse business to Uncle Tom's Cabin (also known as the 14-Mile House) and to a hotel-restaurant called Junction House. In this early 1900 photograph the dense growth of pine and eucalyptus trees obscures the entrances of the two businesses, but people are visible on the road where a bridge has been built over the creek that flowed parallel to Crystal Springs Road.

CONTENTS

ACKNOWLEDGMENTS

San Bruno is well represented by photographs taken over the past 100 years. One of the earliest family photos that I have seen was taken in 1883 for the Silva family. In the 1910s, Fred Beltramo began his illustrious hobby of taking photographs, and he continued snapping his camera until his death in 1975. From his decades of work came the most extensive photographic representation of any city on the Peninsula. Thanks, Fred, for your contribution to this community.

Many others have contributed photos and stories for this book, and I acknowledge their unselfish generosity to future San Brunans. Especially helpful were Gordon Silva, Chief Silva, Walter Jenevein, Michel Coovert, Harper Petersen, Francis Guido, Randolph Brandt, Emile Hons, Charles 'Russ' Hanley, Verle Truman, Joe Halter, "Babe" Flanders, Rena Cotturi, Molly Cozzolino Figone, LaVerne Figone, Margaret Schmidt Mathiesen, Elinor Voss, Eddie Bou, Louise Smith, Agnes Unterine, Tom Grey, Doug Richter, John Schaukowitch, Jack LoReaux, Dennis Sammut, George Edwards, Robert Hensel, Carl Hultburg, Richard Staggs, Lorraine Baker, the staff at the San Bruno Library, and the many unknown contributors to its history archives, and Mitch Postel and Carol Petersen at the San Mateo County History Museum.

I am especially indebted to my wife, Peggy, for her invaluable help during the setting up of this book. Without her suggestions this book would not have been possible.

Darold E. Fredricks has lived in San Bruno since 1963 and is the author of *San Bruno—People and Places*; *Millbrae—A Place in the Sun*; *When Lilacs Were in Bloom*; *Lilacs Two—The 1950s*; and *San Francisco Peninsula—Giants on the Land*. He has written many historical articles for the newspapers, given numerous slide-show presentations and has talked to thousands of Peninsulans during his 25 years of historical research on San Bruno and the Peninsula.

INTRODUCTION

Every town has its unique history, and San Bruno is no exception. The Spanish and Mexican settlers used the area of San Bruno for grazing cattle and horses from the mid-1770s until the end of the Mission Period in the mid-1840s. Its unique geology, with the hills to the west between the Pacific Ocean and the flat terrain along the San Francisco Bay, made it a natural corral in which to let the cattle wander, eat, and produce more cattle. Jose Antonio Sanchez's Mexican grant of Rancho Buri Buri in the 1830s defined the area a little more, but his attempt to put the Rancho on a sound economic base was cut short by his death in 1843. His heirs decided against about raising cattle and sold the land to speculators and the rising class of European Americans who settled here.

The location of San Bruno—14 miles to the south of San Francisco's Mission Dolores and 40 miles to the north of the Mission by San Jose—did not encourage many settlers to stop and build homes until the American Period in the late 1840s. Only then was a roadhouse, the 14-Mile House (later named Uncle Tom's Cabin) constructed along a deep creek that was an obstacle to traverse. In the early 1860s, another roadhouse called San Bruno House was developed along the San Bruno Toll Road that was built in 1859. Owner Richard Cunningham also anticipated the construction of the latest form of rapid transit that was to be built down the peninsula—the railroad. The San Bruno House attracted many sportsmen and visitors for weekend trap shooting, horse races, and relaxation, but the people did not stay to develop a community. By the end of the1880s, another restaurant/hotel facility was erected—August Jenevein's Junction House, ten years before the Tanforan Race Track (where today's Tanforan Shopping Center sits) was built to the north of the San Bruno House. The founder of the Bank of California, Darius Ogden Mills, acquired thousands of acres of Rancho Buri Buri land for his vast estate and dairy, and the great remaining acreage beyond D.O. Mills' land was developed for farms, dairies, and horses by the Sneath, Tanfaran (original spelling), and Silva families. A "core" area of a city was yet to develop.

The El Camino Real bisected the terrain between the western hills and the water of the Bay, but this path played an important part in the development of the Peninsula. The Spanish, and later Mexican, settlers used this dirt path exclusively for travel between San Francisco and San Jose, but after California's admission to the Union in 1850, commercial interests and structures were attracted to it. By the early 1900s, when real estate developers began platting land into 25-foot lots for housing sites, San Bruno began developing as a rural community that was accessible to surrounding communities via the El Camino Real, the railroad, the #40 Interurban Line of streetcars, and the new machine on the scene, the automobile. The community's response to the automobile was slow, only a few auto shops and gas stations, but eventually the businesses realized it was here to stay and began exploiting its appeal and usefulness. Spurred on by the Great

Earthquake of 1906, over 1,400 people moved onto the vacant landscape and by 1914 the city was incorporated as a sixth-class city.

The State of California didn't have the money to build roads in the 1800s, so they issued permits for individuals to build roads and charge tolls for people to use them. The San Bruno Toll Road, which was later renamed San Mateo Avenue, was one of these business enterprises. San Mateo Avenue became the second business avenue in the area, but it attracted little commerce or building until the late 1920s when the economy was ripe for its development. Then the Depression hit the United States and stagnation set in. Few business buildings or houses were built, and the taxing structure was strained to provide adequate government services for the community.

This situation changed when World War II began in the 1940s. The Tanforan Race Track was turned into Navy facilities, the airport became an Army airbase, and the only large business manufacturer to be based in San Bruno, EiMac, became critical to the war effort. There were many thousands of people needed for working in the war factories and the numbers responding for these enterprises inundated the housing market. The thousands of new jobs brought unheard-of prosperity to the area. In the late 1940s, this prosperity triggered the biggest building boom in the Peninsula's history. San Bruno leaped from a city of two square miles of incorporated area to over six square miles of potential homeowners. The western hills, hitherto undeveloped for housing, became a prime target for developers like Perry Liebman, George Williams, and Andres Oddstad. They platted and developed the remaining land of the Mills Addition, and followed this development by building Crestmoor, Rollingwood, Portola Highlands, and Pacific Heights.

The population of San Bruno had been approximately 3,000 in 1930, 4,000 in 1940, jumped to over 15,000 in mid-1940s, back to 10,000 in 1950, then rose steadily until it reached almost 40,000 souls by 1990. The city was nearly maxed out in houses, but the big commercial boom that started in the 1970s was only beginning. A section north of San Bruno Avenue that the U.S. Government had used as a Navy base in World War II was ripe for developing and numerous investing groups developed it. The last large developer in the Bayhill area was the national and international business—The Gap.

Although a few large employing businesses spent a brief time here, San Bruno is essentially a bedroom community. A large number of businesses are essentially service businesses—grocery stores, drug stores, and so forth that are small, personal, and run by people who prefer to deal with small communities. The main story of the area as it is told through history deals with the people who settled here and the small businesses that developed to service this unique community.

Walter Ricci, the son of Henri Ricci, thought big when it came to bicycles. After building this magnificent six-person machine, he opened a bicycle shop in Burlingame. His grandfather Rafael moved his family to San Bruno from Italy early in the 1900s and opened a shoe shop here. He later built the first movie theater, the Novelty Theater, across from the Junction House at the corner of Taylor and San Mateo Avenue. His grandson Walter is still in possession of the original projector that was used in this theater.

One

IN THE BEGINNING

The El Camino Bell has grown to symbolize the spirit of the early missions, but it took a lot of effort to have them designed and placed on this pioneer road. In the early 1900s, a bell designed by Mrs. A.C.S. Forbes, an author of a book on the history of the missions and later president of the El Camino Real Association, was selected as the prototype to be used to mark the road to the missions. By 1913, over 450 bells on 11-foot tall metal pipes had been placed over the 700 miles of the El Camino Real. Unfortunately, the El Camino Bell has been the victim of prosperity and progress in the State of California. With every widening and paving of the El Camino Real, the bells were dismantled and most have never been replaced. Only a few of the original 450 remain to illuminate and mark the path of the main thoroughfare up and down California.

This 1868 map is the first official San Mateo County map concerning Rancho Buri Buri. In 1836, Jose Antonio Sanchez was granted 15,000 acres of land on the Peninsula called Rancho Buri Buri. Sanchez died in 1844 and his ten children were each granted $1/10$ of the Rancho. Many interests immediately contested the division of the Rancho and, as can be seen in this 1868 plat map, there was considerable fragmentation of the land.

Uncle Tom's Cabin was built in 1849 at Crystal Springs Road near the creek that flowed across the El Camino. The roadhouse flourished and became a landmark on the San Francisco Peninsula. Stagecoaches called "mud wagons" (passenger coach pictured) stopped for food and water before completing the long trip to San Jose or San Francisco.

In the early 1900s, Uncle Tom's Cabin was prospering as a roadhouse, but the means of transportation were changing. In this image a buggy can be seen alongside a newly introduced means of transportation—the automobile.

Whether you ate on the enclosed front porch or in the numerous rooms on the first floor, the food at Uncle Tom's Cabin was reported to have been excellent. Many of the community organizations met here to enjoy a sumptuous meal of steak, salad, and dessert for a cost of about a dollar. There was a huge bar downstairs, slot machines in a back room, and some rumors circulated that other games of chance were to be played on the second floor.

On August 7, 1912, a huge celebration was held on the grounds of Uncle Tom's Cabin. The State had begun construction on the first paved highway road in California since forming the State Highway Department. The celebration lasted all day with overflow crowds eating beans and barbecued steak in the adjoining city park along the El Camino Real.

In the 1770s, the El Camino Real was a path that the Spanish developed into the major road for traveling up and down the Peninsula from San Jose to San Francisco. A toll road to San Francisco was opened across from Uncle Tom's Cabin in the late 1850s, making this the busiest corner in northern California. In the 1920s, the traffic at this corner decreased when it was bypassed by the construction of the Bayshore Highway to the east of San Bruno.

The original property of Uncle Tom's Cabin consisted of 30 acres in the 1800s, but in the early 1900s, land was sold for housing developments in the Huntington Addition. By the 1940s, another large section of land had been sold, reducing the estate to the site where the original building had been constructed.

The final demolition of Uncle Tom's Cabin occurred in 1949 after the structure was condemned by the fire marshal due to fire code violations. The Grace Honda auto dealership now occupies the site.

Two miles south of Uncle Tom's Cabin, Juan Sanchez built the 16-Mile House at Center Street and El Camino Real in Millbrae in 1872. It offered food and entertainment and was the center of the northern Millbrae and Lomita Park community for almost a hundred years. It was razed in 1971.

In 1905, the Third Addition was platted and it included a unique feature—the "Heart Area." Actually, it exhibits double hearts in the street layout. Another striking feature in this early 1930s photo is the tree-lined El Camino as well as the numerous trees on the Uncle Tom's Cabin roadhouse property. At the bottom of the photo is the Cribari Dairy at the end of First Avenue. The Cribari family eventually left San Bruno and were successful in the wine business in the San Jose area. This is a section of a large old map; the names of streets have been changed since the 1930s. The #40 Line, next to the Southern Pacific Railroad (or SPRR, bottom), is indicated by the word "Market." The #40 Line was named the Market Street Railroad on this map.

In the 1850s, the city of San Francisco became the destination of travelers coming up the Peninsula, and the San Bruno Toll road (later renamed San Mateo Avenue) was built in 1859. It started from the Uncle Tom's Cabin area on the El Camino Real and crossed the marshland and San Bruno Canal on its path toward the east side of San Bruno Mountain. It ended in San Francisco and saved miles and time in travel. In 1861, Richard Cunningham built a hotel and bar—The San Bruno House—next to the toll road on land the San Francisco and San Jose Railroad (later the SPRR) would cross a year later.

In 1863, a mile north of Richard Cunningham's San Bruno House, the workers of the San Jose and San Francisco Railroad constructed a stone bridge over an east-flowing creek. The granite bridge, made up of 105 stones weighing up to 1,500 pounds each, has a 10-foot-high archway with 16-foot-long walls on either side. In May 2002, Epperly Masonry Restoration, a Point Richmond company, moved the bridge out of the way for the BART subway construction. Ben Epperly, a stonemason, restored the bridge for the BART project, and it now continues its intended function of allowing the creek water to flow to the San Bruno Canal.

The #40 Interurban Trolley Line tracks ran to the left of the SP train station at Euclid and Huntington before 1916 when this station was moved to San Bruno and San Mateo Avenues. To the right of the station, the SP tracks run to San Francisco and down the Peninsula. Noyer's Ess Pee Saloon is to the left where Huntington Avenue is now. The Tanforan Race Track is visible at the far end of the #40 Line tracks.

Two
TRANSPORTATION

The SP railroad station at the corner of San Bruno and San Mateo Avenues was moved from Euclid and Huntington Avenues in 1916. A shed and passenger shelter were added to it at this site. John O'Connor moved to SB in 1905 and became the resident station agent until his retirement in 1947. He stoked the potbelly stove and sold tickets to the many residents who relied on the train for their transportation to work. The station was razed in 1963, and the San Bruno Lumber Co. moved to the site. It closed in 2001.

The restored Southern Pacific steam engine, #2472, steams down the Peninsula on a nostalgia run, passing the Millbrae train station, carrying Santa Claus to see the kids at each whistle stop on the line at Christmas time. The train also provides many railroad buffs with a rare ride on a steam train when it makes a yearly run to Gilroy's Garlic Festival.

Gus Jenevein's Junction House on this triangular corner surrounded by the El Camino Real, San Mateo Avenue, and Sylvan Avenue in San Bruno was a welcome sight to travelers. A horse and wagon are visible on the unpaved El Camino Real in San Bruno (to the west of Junction House) in this late 1800 photograph. The signs tell you that this is "Mission Road" and it is 14 miles to San Francisco.

Across the El Camino from Uncle Tom's Cabin, August Jenevein and his family built and lived in the New Orleans' French-style hotel, named Junction House. Later, the Jenevein family had a house built at 447 San Mateo Avenue.

The Jenevein family, shown on the porch of the Junction House c. 1908, are Jule, Amelia, August Jr., Luvina, George, Viola, Hortense, father August Jenevein, mother Amelia, Hilda and Joe.

August Jenevein and wife celebrated their 25th wedding anniversary with family and friends in 1908. They are gathered for this picture on the front steps of their hotel, Junction House. The building was razed in the 1930s and a gas station built at the corner.

In 1871, Custodio Silva purchased 29.21 acres north of Interstate 380 on the El Camino Real from Paula Sanchez Valencia's son, Antonio, both descendants of Jose Antonio Sanchez. Custodio had worked for the Miller and Lux cattle business in South San Francisco, saved his money, and put $5,000 (in gold) into this land investment where he was going to buy, break, and sell horses. Shown in this 1883 photograph are four of his six children are in this 1883 photograph. From left to right are Matilda, Manuel, Trinidad, and Amelia (Mercedes and Robert are not pictured). Custodio built an empire of land, including the division now the Brentwood area in South San Francisco, the Silva tract in Millbrae (housing the City Hall, shopping mall, and other popular destinations), property with oil on it in La Honda, as well as other investments.

In 1868 at the age of 23, Emelia "E.M." married Custodio Silva after meeting him at the Mission Dolores and falling in love. Both she and her husband were born in Chile and migrated to the San Francisco Peninsula. In 1871, they built a horse ranch along the El Camino Real into a prosperous enterprise. At the ranch they raised six children: Trinidad, Amelia, Matilda, Manuel, Mercedes, and Robert. Manuel married Ignez Diaz from Atherton in 1905, and they had four children, named Richard, Hortense, Robert "Duke," and Gordon. The Manuel family sold the ranch and moved to 125 San Luis in 1927.

The Silva family was very popular on the Peninsula and held formal dinners in this lovely dining room at 125 San Luis Avenue. The wood-paneled walls gave this room an air of dignity and quality. The Silva family personified these qualities in their lives.

In 1903, the #40 Interurban Line began running from San Francisco to San Mateo. Here a #40 Line car heading north slows for the San Bruno Avenue crossing. A man in the tower controlled the "gates" that stopped car traffic while the #40 cars passed across at San Bruno and San Mateo Avenues. The SPRR depot was situated at this same intersection.

Proceeding cautiously, a #40 trolley—heading south—approaches the San Mateo Avenue crossing.

The #40 Interurban Trolley Line ran from San Francisco to San Mateo from 1903 to 1949. Here a siding line runs under the first Tanforan Race Track stands that were then on the east side of the race track, facing west, next to the SPRR tracks and the #40 Line.

On January 24, 1910, the first airplane flight in the San Francisco Bay Area was attempted by Louis Paulhan. It took place at the Tanforan Race Track during an air promotion event. Thousands watched while Paulhan flew for eight minutes, soaring to an altitude of 700 feet. On January 11, 1911, Eugene Ely took off from Tanforan and successfully landed on a 30-by-130-foot platform constructed on the armored cruiser *U.S.S. Pennsylvania*, anchored in San Francisco Bay. Ely's historic flight marked the first carrier landing and take-off, signaling the beginning of naval aviation.

In 1899, the first viewing stands and racetrack were built in San Bruno between El Camino Real and the Southern Pacific railroad tracks. The racetrack attracted horse racing seasonally and was a great economic boost to the people of San Bruno. In 1917, the grounds were used to pitch tents and train the army of California Grizzlies for their anticipated use in World War I. Gambling was outlawed in the 1910s, and the racetrack stands were torn down in 1918.

The second viewing stands of the Tanforan Race Track were constructed in 1923 along El Camino Real. Horseracing began again, and, in the 1930s, pari-mutuel betting was permitted. In the late 1930s, Seabiscuit was moved to the West Coast where he began breaking records at Tanforan Race Track. He ran a fabulous series of races and became the industry's biggest money winner in 1938.

During World War II, the Tanforan Race Track was closed and used in 1942 as a site for the relocation center of many Japanese of Northern California. After the Japanese left, the U.S. Navy took over the facility and used it as a Naval base where sailors were assigned to Pacific Ocean fighting areas.

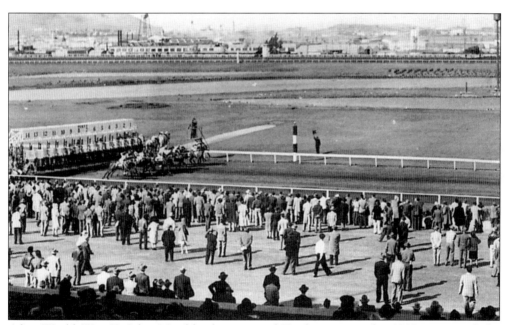

After World War II, John Marchbank, owner of Tanforan since the 1920s, reopened the Tanforan Race Track after remodeling the track and stands. Seasonal horse racing again resumed during the 1940s and 1950s.

The racetrack was destroyed in an extraordinary fire in 1964, bringing decades of racing entertainment to the finish line.

In 1972, the land where the Tanforan Race Track stood from 1899 to 1964 was the site of construction of the Tanforan Shopping Center. To the north of the Tanforan Shopping Center, the Town Centre was constructed in 1989.

A good view of western San Bruno is seen in this excellent 1947 aerial photograph. To the left are the Navy barracks, below them is Tanforan Race Track, to the center is the Golden Gate Cemetery, and Brentwood (in South San Francisco) is to the right. Plenty of wide-open spaces existed at the time, occupied by vegetable growers farming their plots.

The wonder horse of the 1930s, Seabiscuit used the Tanforan Race Track as his home base and training track. Charles Howard, Seabiscuit's owner, lived on the Peninsula and also had a ranch at Willits where Seabiscuit lived out his retirement. Emile Hons and Don Frate, managers of the Tanforan Shopping Center, paid homage to Seabiscuit by having a magnificent statue created and placed at the center when it opened in the 1970s.

Congress established the Golden Gate National Cemetery in 1937. The 161.5-acre tract was purchased from the Sneath family by the War Department in 1938, and the first burial occurred in 1941. Official dedication was on Memorial Day, 1942. This cemetery has become the final resting place for over 115,000 veterans. In 1977, the Avenue of the Flags was formed for the Memorial Day observance with the aid of San Bruno American Legion Post 666.

This view from Rollingwood shows the extent of development of the Golden Gate National Cemetery in 1948. The Junipero Serra Highway (also known as today's Interstate 280) connected with El Camino Real by way of Sneath Lane. The El Camino Real was no longer designated as Highway 101 at this time as the Bayshore Highway was constructed and redesignated Highway 101. The World War II barracks "city" called Lindenville can be seen in the area of South San Francisco's future industrial park, and the Starlite Theater Drive-In on Spruce Avenue is to the left of Lindenville. Brentwood, the property once owned by C. Silva, was almost three-fourths complete with housing development at the time. On Sneath Lane, the Avensino-Mortensen Nursery hothouses still line the avenue to the north of the "Navy Land" barracks. Tanforan Race Track is to the east of these two facilities.

Junipero Serra Highway was completed in the late 1930s to Sneath Lane where it connected with El Camino Real. The newly opened Golden Gate Cemetery is to the right and Rollingwood to the left. South San Francisco's Brentwood area is to the upper right in the photo.

Mills Field (now the San Francisco International Airport) as it appeared in the 1920s. Bayshore Highway had just opened from South San Francisco to Burlingame and ran to the west of Mills Field. South San Francisco is to the north in the picture at the base of the San Bruno Mountain.

Fred Beltramo became an avid airplane pilot in the 1920s and photographically documented San Bruno and the surrounding area from his open-cockpit biplane. His photographic contribution to San Bruno is the most complete set of pictures of any city on the Peninsula. Here he, on the left, is captured in a photo with Joe Jenevein.

The area where the San Francisco Airport was developed in 1927 had been a popular site for the new fad of flying airplanes since 1910, when Paulhan flew for the first time out of the air show at the Tanforan Race Track. Many took their first flight from the dirt runways or just went to the airfield to gawk at the new-fangled flying machines. Here Louis DellaMaggiora and Raphael Ricci wait for Fred Beltramo to give them a ride in his airplane.

When automobiles first began traveling on the El Camino Real, the owners lived with the fear of running out of gasoline, mechanical problems, and breakdowns. Businesses quickly sprang up on the old Highway 101 (or El Camino Real) to serve the stranded motorist. In the early 1900s, August Jenevein's son, August Jr., opened his auto repair shop, The Cabin Garage. After Jenevein, many owners operated on this site, but this building was torn down in 1961 to make way for the widening of the El Camino. In 1989, the City of San Bruno purchased the site and the existing building for $1.2 million and converted it for use for the Municipal Cable TV offices.

Many of the first stations to service automobiles were simple structures with a neatly uniformed attendant waiting to service your car at the one or two gas pumps in front. While pumping the 10¢ a gallon gasoline, the attendant washed your windshields, checked the oil in the engine, along with the air in the tires if you requested it.

Before the advent of the modern automobile, early models sometimes were a transition between buggy technology and the modern concept. The headlights were large, but lit the roadway poorly. Flat windshields could be lowered, thus allowing more breezes to cool the passengers who sat on stuffy leather seats that got hot in the sun. The ever-present toolbox sat on the running board and was needed frequently for repairs of the motor or the tires. With the advent of mass automobile production, rapid evolution occurred and electric starters, sealed-beam headlights, tubeless tires, and numerous other conveniences helped develop the modern, almost-trouble-free automobile that exists now. The vehicle pictured here is believed to belong to either the Silva family or the Cribarri family who ran a dairy at the south end of 1st Avenue. In the background can be seen the San Bruno Lumber shed that sat between Huntington and Mastick on Angus Avenue.

This stretch of San Mateo Avenue in the 1920s allowed cars and horses on the same road. The kids playing in the vacant lots along the 600 block had little fear of the few automobiles that passed the "billiard" building that was to become Artichoke Joe's in the future.

This 1930s photo of San Bruno's two square miles was taken by amateur pilot and amateur photographer Fred Beltramo. The limits of the city are immediately evident, as is the Tanforan Race Track that dominates the northern section of the city. The eye captures the prominence of the tree-covered grounds of Uncle Tom's Cabin at the junction of San Mateo Avenue and the El Camino Real. The roadhouse stood at this spot for 100 years, serving travelers and citizens of the area.

Three
FRED BELTRAMO

The Beltramo house at 677 Masson became a center of social activity and business in San Bruno. Nat Beltramo and his family fled the ravages of the San Francisco Earthquake in 1906 and settled in the fledgling village of San Bruno. A desire to succeed, drive, and hustle, combined with smart business sense and frugal living, produced a successful draying and coal business. After Nat died in 1919, his son Fred dropped out of school and ran the business. The advent of natural-gas heating shut down the business, and Fred went on to pursue many other careers in San Bruno.

Natale "Nat" Beltramo came to the U.S. in 1880. While living in San Francisco, he married a girl from Italy, Olimpia, in 1900. The 1906 Earthquake forced him and his family to flee to San Bruno for safety, and he remained there until his death in January, 1919. Hard work rewarded him with successful draying and coal business that his wife and son continued after his death. The Beltramo family was recognized by Congressman Lantos as a founding family of San Bruno and their family history was recorded in the October 12, 1987 Congressional Recod. In this photo, the Beltramo family poses for a protrait at the 1915 San Francisco Pan Pacific Exposition. In the front row Minnie, Teresa, and Mary. In the back row are the mother, Olimpia, son Fred, and father Natale "Nat."

Fred and Una Stone were married in 1936, and this union produced two children, named Pamela and Tony.

Another good photo taken by Beltramo, looking south, shows distinctly the former San Bruno Toll Road (now San Mateo Avenue) and the tree-lined El Camino. The Belle Air district (on the left) is sparsely populated, the "Heart Area" shows up clearly.

Beltramo, taking photographs from the top of his barn, gives us a wonderful view of the sparsely-built First Addition and San Mateo Avenue in the early 1920s. Two houses can be seen under construction by Prosper Bou at 686 and 698 Masson Avenue. At P.J. Sullivan's grocery

Looking east in this early 1920s photograph from Fred Beltramo's three-story barn, you can see that San Bruno's Belle Air addition is thinly populated. Meanwhile, the main street, San Mateo Avenue, has very few buildings. To the left is Joe's Pool Parlor, the rear view of 661 and 657 San

store at the corner of Kains and San Mateo Avenues you could buy insurance and real estate, as well as have papers notarized by a notary public. Joe's Pool Parlor (later to become Artichoke Joe's Casino) is in business at 676 San Mateo Avenue.

Mateo Avenue (now a parking lot), a few private houses next to 609 (the DeBenedetti building), and, finally, to the right at Angus and Masson is Nick Drescher's Hall (used for various purposes, such as a dance hall, church, wedding receptions, and so forth, through the years).

To the south from the Beltramo barn can be seen Nick Drescher's Hall at Angus and Masson. Across the street from the hall are what may be three "earthquake houses" (houses built for refugees after the 1906 earthquake in San Francisco. Some were transported down the Peninsula). The left building is still standing, but modified. The other two on the right were razed for the parking lot that stands now. At the end of Easton Avenue can be seen Newell's Bar, and to the right on Easton is the home of San Bruno's first mayor, Louis Traeger.

Fred was a hard-working, well-liked individual. The business that he inherited from his father prospered until the late 1920s when natural gas began replacing coal as a fuel. The draying business could not sustain the enterprise and it was finally dissolved. This photo shows Fred (in the driver's seat, naturally) with a friend in one of his trucks.

In this Fred Beltramo barn's-eye-view photo, Fred captures the rural character of San Bruno in the 1920s. To the southwest is 649 Easton (the Drescher house) and south of it is the former mayor Louis Traeger's house. On El Camino Real at Angus Avenue can be seen Prosper Bou's home that became the site of the International House of Pancakes in 1968. South of the Bou house is the Community Methodist Church.

Northwest of the Beltramo barn can be seen the first San Bruno City Hall (look for the flag pole). It is just south of the Hoop's family house (now the Melody Toyota auto dealer). On Hensley Avenue can be seen men at work paving the street. St. Bruno's Catholic Church and Rectory are prominently displayed at the corner of Hensley and San Bruno Avenues, and to the right is the oldest business in San Bruno, LoReaux Plumbing. In the lower area of the picture is Kains Avenue.

Looking east from Green and Kains avenues, the 3-story Beltramo barn hat was built in 1912 can be seen. Because it was the tallest structure in San Bruno at the time, the fire department persnnel used it to climb in their training exercises.

To the northeast of Fred's barn can be seen Frank Valentine's home at 304 Kains and to the upper right are the trees that surrounded the San Bruno House. To the right of the trees is the DellaMaggiora home and grocery business. At the bottom of the picture is a good view of Fred's draying/coal business storage yard.

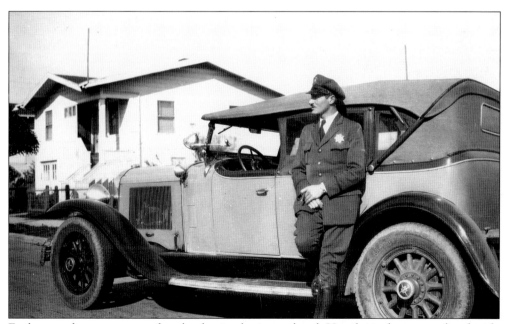

Fred pursued many careers after the draying business closed. Here he is shown standing beside the San Bruno Police Department's patrol car, a Willis-Knight. The police chief, Russ Cunnigham, called it "the classiest auto in San Bruno at the time." After serving as a policeman, Fred sold insurance, but finally concluded his working career as a postal employee.

In this late 1930s photo by Fred Beltramo, Tanforan Race Track is at the top of the photo and Uncle Tom's Cabin sits among the clusters of trees along the El Camino Real. The "Heart Area" is to the right and Belle Air at the upper right. San Bruno had about 4,000 people living here at the time.

Four

GOVERNMENT

At age 17, the lovely Edith Schmidt, daughter of the butcher Henry, poses in the full regalia she wore as "queen" of the dance that celebrated the city's incorporation. To raise money for the festivities, a "contest" that cost 10¢ a vote was set up, and Edith received the most votes. The city's festivities consisted of a parade down San Mateo Avenue and a dance on the recently paved El Camino. Edith's escort was Harry Cook. A year later they were married and settled down in San Bruno to live.

On December 18 and 19, 1914, 471 citizens of San Bruno voted for incorporation, with 296 voting to retain the status quo. Louis Traeger, who received the most votes, was sworn in as the first mayor at A. Hyde Green's real estate office. The first council meeting was held at 444 San Mateo Avenue in Green's Hall. The council and mayor moved their meetings to the "Little Tin Schoolhouse" on El Camino Real and that structure became the Town Hall until the new building was built at 567 El Camino Real in the 1950s.

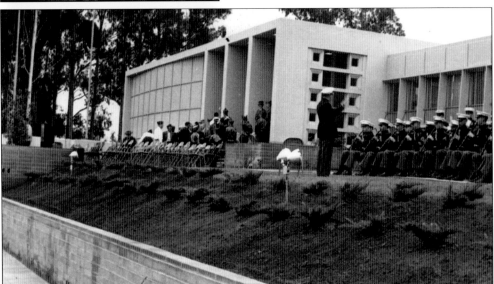

On September 19, 1953, the new San Bruno City Hall at 567 El Camino was dedicated amid much pomp and circumstance. City Attorney Rudolph Rapsey was the master of ceremonies and Congressman J. Arthur Younger gave the dedication speech as Mayor J.V. Fitzgerald Jr., City Clerk Ralph Woodman, San Bruno City council members, and the public looked on. The U.S. Marine Corps Band played, the Reverend Murdock, pastor of St. Andrew's Episcopal Church, gave the Convocation, and the American flag was hoisted to ensure a successful dedication. The city hall complex sits on a 3.4-acre site that was purchased from George Williams at a cost of less than $5,000. The 1953 building with 14,500 square feet of floor space cost $244,125 and was paid for immediately at the insistence of councilman William Maurer.

The crowds turned out on September 19, 1953, to hear the speeches and the Marine Corps Band at the San Bruno City Hall dedication at 567 El Camino Real. Traffic must have been light in 1953, as the people are standing two lanes out onto El Camino.

The city of San Bruno sponsored a contest to come up with an identification logo in 1954. Diane Nolan, a student at Capuchino High School, designed a striking city logo. Recognized immediately as a positive image for the city, it was put on the city's equipment and automobiles. Here Diane poses with Steve Bottassi after the new logo was put on one of the city's police cars.

Gathering in the San Bruno City Hall in 1983, a number of pioneer children, now prominent citizens, stand proudly in front of the photographic display that honors Fred Beltramo. Pictured, from left to right, are Ralph Holliday, his wife Margretha Stodick, Irene Oppenshaw Efford, husband Leonard, and Eddie Bou.

About 1925, Mrs. Bellamy of 617 Easton established a library in her notions store. Kids bought candy and read or checked out books that were stacked on the numerous shelves. In 1937, newly appointed librarian Mrs. Decima Allen took over at this site until a larger city library was built in 1939. The new library was on city property purchased from the Jenevein family on Jenevein Avenue between El Camino and San Mateo Avenue. This structure was torn down when the new library opened in 1955 at Angus and El Camino.

In 1955, the library at Angus and El Camino Real was built with the funds available. During "Hard Hat" Willie Maurer's 26-year reign as councilman, he insisted everything bought by the city be paid for immediately with cash. The new library began taking on many more functions than were originally intended in the 1950s. Now, besides providing information and lending books, audio and videotapes are available. In addition, the computer age has hit the library system, and the city provides Internet access on numerous computers.

The Volunteer Fire Department was well represented in this September 9, 1914 parade. The San Bruno Fire Department was an all-volunteer organization that started in the 1900s. In 1916, the city council appointed a fire commission that organized an official fire department in 1917. Joseph Senger became a part-time fire chief, and he was appointed full time in 1938. In 1956 Herb Freitas became the second fire chief, and served until retirement in 1976, when Harper Petersen took over. In 1988, Tom Ott became chief, followed by Berry Johnson in 1998. In January 2002, Dan Voyer began serving as chief.

Posing before their 1925 LaFrance fire truck in this early 1930s photograph, volunteer firemen stand at the firehouse at 618 San Mateo Avenue. From left to right are the following: (back row) Sylvan Selig Jr., Bill Schade, Jim Foley, Bill Titcomb, Walter Sullivan, and ?; (front row) Jack Karman, Francis Pene, Joe Singer, Louis Traeger, Happy Beckner, and Tom Weidemann Sr.

This firehouse was moved to 618 San Mateo Avenue in 1916 by jacking it up and "rolling" it down on logs from its Jenevein Avenue site. It became the social center of the community as fund raising for fire services and equipment was an on-going necessity. Whist card playing parties generated a lot of money for fire hoses, trucks, and uniforms for the fire department.

On May 5, 1950, the Volunteer Fire Department held its annual dinner in the old fire house at 618 San Mateo Avenue. Seated at the left table (clockwise from the left) are Gene Ducoing, Charles Pene, Harry Cook, Gus Jenevein, Paul Gruber, George Jenevein, ?, Milford LoReaux, Charlie Hart, ?, Mike Millerton ?, Mayor Bill Farmer, Councilman Lyman McGuffin, ?, Francis Pene, ?, Dennis Stevensen, Bill Costello, and Bill Marr. At the right table are Bill Titcomb, John Schaukowitch, Fred Allen, Pop Fisher, Sal Slamirs, Councilman William Maurer, councilman John Murphy, George White, Herman Sick, Norman Skellenger, Steve Lombardi, Judge Rudolph Rapsey, Roy Jacobsen, Fred Madden, Bill Maggard, ?, Henry Bud Maher, and Carl Hultberg. Standing, from left to right, are ?, ?, Gino Beneditti, Ed Wilcox, Harry Love, Fire Chief Joe Senger, ?, Al Cameron, Pop Henry, Hap Beckner, Gus Magnuson, Les "Doc" White, and Ken Maybe.

CENTRAL FIRE STATION

Here stands San Bruno's Fire Department in 1966. From left to right are the following: (front row) George Roumbanis (capt.), Herman "Hank" Balanos (capt.), Leland "Lee" Moore, Herbert "Herb" Freitas (chief), Harper Petersen (fire marshal), and Gus Felix (capt.); (middle row) Fred Schoene, Pete Norcia, Dick Checchi, Bill Alexander, Duke Dold (capt.), Ray Gomes (capt.), Mike Coscine, unidentified, Jim Curran, and Jess Doran; (back row) Bill Wilson, Don Gonos, Bob Catalina, Dave Hayes, Lee Spivey, Tom Ott, Ron Robertson, Cliff Middendorf, Harry Vogel, Bob Hensel, and Bob Stewart. Not pictured are Mike Schade and George Edwards.

In 1949, a year after being constructed, a fire began in the back area of the Lucky Store on the El Camino Real. The San Bruno Fire Department responded at once, but within an hour the fire had gutted the entire structure.

The El Camino was designated as Highway 101 at the time of the fire, and it was closed for several hours while firefighters tried to contain the fire. Uncle Tom's Cabin, to the right, was not damaged in the fire, but it was razed within a year due to fire code violations.

A meager force of policemen during the 1910s and 1920s protected San Bruno. They were paid low wages and had to furnish their own uniforms, weapons, and sometimes even cars while serving the city. In the 1920s William L. Maher was appointed deputy marshal, and he became the first police chief in 1927. He was a typical constable in the 1920s and 1930s and became one of the most respected citizens in the community. Maher served as police chief until 1978 when Russell Cunningham took over the position. Cunningham was followed by Frank Hedley in 1976, Joseph Palla in 1995, and Lee Violett in 1998.

Steve Botassi joined the San Bruno police ranks in 1945 and became the first "three-wheeler" motorcycle policeman on the force. He worked crowd control at the parades and directed traffic as well. Here he sits proudly showing off his three-wheeler in front of his house on Elm (directly west of the police station).

The officers and staff of the San Bruno Police Department strike a pose in the 1957 photograph on the steps of the City Hall at 567 El Camino Real. From left to right are the following: (front row) Bill Costello, Fred Wootan, Russ Cunningham (second police chief), William Maher (first police chief), Jack Doris, and Leo Flynn; (second row) George Cellilo, Bill Sweeney, Bill Rogers, Dick Walrod, Gene Nelson, Art Brittain, unidentified, Steve Bottassi, and Bert Mohrhouse (dispatcher); (third row) Joe Diprinzio, unidentified, ? Garbardino, unidentified, Fred Freitas, Dick Fandrich; (fourth row) unidentified, Agnes Unterein, Margaret Stallings Wootan, and Dixie Morgan Flynn.

The Police Department vacated the quarters they had occupied since 1953, and in 2002 they moved into a new, larger, modern building at the BART station near the Tanforan Shopping Center.

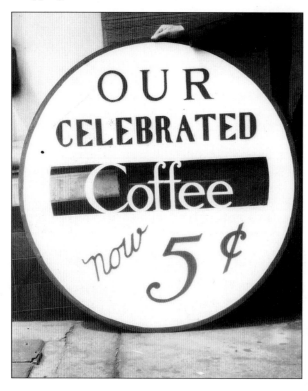

Coffee and a donut became a local institution early in our history.

The old "San Bruno Toll Road" was built in 1859 by enterprising Redwood City investors who were authorized by the State to charge a fee for its use. By 1900, the name was changed to San Mateo Avenue to distinguish it from the San Francisco section called San Bruno Avenue. Fred Beltramo took this picture in 1921 when this section in San Bruno was paved for the first time. When the curbs were to be constructed, sacks of cement were loaded into the cement mixer, and these hardy men completed the project.

One of the most important machines in constructing a road was the steamroller. This machine is being unloaded from the railroad siding on First Avenue where it was transported to San Bruno to pave the roads in 1921 and 1922.

An important part of the City Council's duties was inspecting improvements of city buildings and roads before payment to the contractor was approved. Here San Bruno City Council members inspect the street at the corner of Kains and Masson Avenues.

Although the streets in the downtown area were paved in the early 1920s, the streets to the west of El Camino Real had to wait until the 1930s for their paving. In this mid-1920s photo of the Weppener family, mom Stella, and her children (Aileen and Madeline) are enjoying the rural setting of old San Bruno. The street in front of their Chestnut Avenue home would have to wait its turn.

Five
FAITH AND EDUCATION

San Bruno, Catholic School, San Bruno, Cal.

Catholics, who had been meeting in Cody Hall at 812 Mills Avenue, acquired a site at the corner of Hensley and San Bruno Avenues about 1907, with the generous help of the Silva family. In 1908 construction began with volunteer labor of church members. Built in the style of the Santa Barbara Mission, this St. Bruno's Catholic Church became a parish church in 1912 and continued serving the parishioners until it was declared unsafe by today's earthquake standards. It was razed in 1960 and a new structure was built on the corner of Green and San Bruno Avenues.

The exterior view of St. Bruno's Catholic Church grew ever more beautiful as the ivy climbed the walls, softening the hard edges of the stucco.

The young boys pictured here served as altar boys in 1938. From left to right they are, (front row) Raymond Moore, Dan Miller, and George Mutto; (center) Billy Fritz, Leonard Mosier, Tony Longhetti, and Bob Collins; (top) Bob Scoffield, Bob Rosen, Gordon Martinelli, and Gordon Woodman.

When the St. Bruno's church became too small for the parish, St. Roberts was built in 1958 at the corner of Crystal Springs Road and Oak Avenue. A Catholic school had been built north of the church in 1949.

At the corner of Masson and Angus Avenues, the carpenters built a meeting hall in early 1910. Nick Drescher acquired the building in the 1920s and, after enlarging the rear of the building for living quarters, he rented the structure out for different activities—a dance hall, a roller skating rink, a meeting hall, and a place for church services and even weddings. "N.D. Hall" became a very popular recreational spot.

This magnificent view looking west toward downtown San Bruno in 1918, taken by Charles Brose, shows the still sparse development of the village four years after incorporation. To the right, on San Mateo Avenue, the post office is at 609 and to its left can be seen the one-story carpenter's hall (N.D. Hall) at Angus and Masson. N.D. Hall became the social center for the northern area of San Bruno. To its left (in the center of the photo) can be seen 583 (Madden's Progressive Grocery Store) and 589 (a hardware/electrical shop). The photo was taken from San Bruno Lumber at Angus and Mastick Avenues.

In the early 1900s the Easton family, which was related to the Mills family of Millbrae, platted and sold land for houses in what became known as Lomita Park. Mrs. Easton donated land for St. Andrew's Episcopal Church at Santa Clara and El Camino Real. The congregation moved to a new church next to San Bruno Park in 1958.

The Community Methodist Church was formed, and a one-room wooden structure was built next to a creek at 560 El Camino. The only surviving thing left when it burned to the ground in 1909 was an ice-cream freezer owned by the Eptworth League. Undeterred and undaunted by this misfortune, the congregation built a new church that was completed in 1918. In 1941, this church was remodeled and greatly enlarged.

The membership of the Community Methodist Church steadily grew and numerous improvements were made. A new sanctuary and Sunday school wing were added and the old sanctuary became a social hall.

St. John's United Church was begun in 1921 while its congregation held services temporarily in N.D. Hall on Angus Avenue. The church was completed in spite of a windstorm that almost blew the partially-built structure over. Many improvements and additions later, the church now occupies almost the entire site at Mastick and Sylvan.

In 1949, St. Thomas Lutheran Church meetings were moved to a new building at the corner of Crystal Springs Road and Poplar. Shortly after constructing a south addition to this building, the church group moved to the west of San Bruno, into a new structure at 250 Courtland. It is now called the San Bruno Chinese Church. The site at 310 Poplar is now occupied by the Wat Buddhapradeep of San Francisco.

In 1957 the Church of the Nazarene began serving its members at Hawthorne and Jenevein Avenues.

Occupying the area where Toribio Tanfaran (original spelling) and family farmed in the 1800s is the Church of Jesus Christ of Latter Day Saints. Construction started at 975 Sneath Lane in 1986 and was completed in 1987.

After starting in N.D. Hall in the late 1930s, the First Baptist Church congregation bought the entire block of land between Acacia and Cypress Avenues along Crystal Springs Road in 1940. Several additions later, it now occupies the entire block.

In the early 1900s real estate developers platted San Bruno for lots in the First, Third, and Fourth Additions. Many houses were built and parents demanded that facilities be built for the education of their children. In 1907 the pioneer real estate company, Hensley and Green, donated a 25-foot-wide lot at 744 El Camino Real. A one-story, two-room building with pressed-tin siding that simulated bricks was erected. Called affectionately the "Little Tin Schoolhouse," it was used for classes until it became overcrowded. A new facility, Old Edgemont Elementary School, was built in 1910 on Elm Avenue. In 1915, the San Bruno City Council moved into the "Little Tin Schoolhouse," and it served as a city hall until 1953.

After use as a school, a city hall, and a hat shop, the "Little Tin Schoolhouse" was torn down in 1963. The automobile dealership, Melody Toyota, utilized the property next to it for their auto business, and the school site became a driveway.

Walking to school was a must in the early days of education but, once there, the children at the Edgemont Grammar School were provided with good teachers, a wooden desk shared by two students, and cast-iron radiators for heat. The students had ample playgrounds around the school building for recreation. During bad weather they could eat their lunches in a basement that doubled as a recreation area.

In this photo, taken in the mid-1920s, you are looking northeast from the 400 block of Chestnut. Three-storied Edgemont Elementary School is in the middle left on Elm Avenue. In 1904 the realtors planted trees in the San Bruno Park Addition to induce people to buy lots in this treeless, barren terrain. The trees seem to be thriving.

The "Little Tin Schoolhouse" on El Camino rapidly became overcrowded, and in 1910 a new, three-story wooden structure was built on Elm Avenue. This school was called Old Edgemont Grammar School, and it served the community until 1957 when it was razed. The present-day San Bruno Park District offices were built on the site.

This group of very well-dressed school children at Edgemont Grammar School appears to be taking their education very seriously. Big bows were in fashion for little girls in 1919, as well as high-topped shoes and boots.

In this happy 1938 Edgemont Grammar School group photo, high-topped shoes were now out of style for the girls and there is not a hair-bow to be seen. Lilly Jow, third from bottom-right, was from a family of flower growers west of San Bruno. Other students, from left to right, are (front row) Leona Rhoads, ? ,Carol Lyons, Karline Kissenger, LaVerne Love Figone, Doris Bush, June Ru Chival, Lilly Jow, Eleanor Wendin, and ?; (second row) Marie Brown, Barbara Sands, Gerry Stodick, LaVerne Oltaker, Shirley Lang, Pat Nolder, Fleticia Ballam, and Raymond Rubin; (third row) Joe Wolf, John Perotti, Robert Gsell, Paul Olk, Red ?, Edward Hill, Roland Abraham, and Harry Stookey; (back row) Robert Bush, Hugh Weimand, Ted Texera, Herbert McGee, and Jesse Bonds.

On February 21, 1941, just over five acres were purchased from George Williams for a new Edgemont Grammar School. Facilities were completed in October 1941, and the last graduating class of Old Edgemont occurred January, 1942. The "new" Edgemont was renamed in honor of long-time board member, Mrs. Decima Allen, in 1956. Here is shown the second grade of 1980–1981. They are, from left to right: (front row) T. Diaz, I. Ruiloba, C. Linan, S. Cha, S. Ellis, R. Gibbons, and T. Kulkarni; (second row) Mrs. Mackewicz, J. Walsh, R. Diaz, J. Ragole, J. Custodio, J. Howell, N. Shukry, Y. Gordon, K. Snowberg, and Mrs. Figone (teacher aide); (third row) T. Botting, C. Lavatai, R. Fassler, C. Lin, M. Quinones, C. Siordia, and C. Franz; (fourth row) M. Pisani, O. Quiroz, S. Bowman, M. Pahulu, K. Hsu, and B. Connors.

Community leaders of San Bruno at installation of school board members in 1960 include, from left to right, (front row) ?, ?, Willard Engvall (superintendent of schools), Mrs. Engvall, Decima Allen, Mrs. Tickler, and Mrs. Wetchell; (back row) John McClurg, Edith McClurg, Marge Orton, Bill Orton, Han Snarr, Mrs. Snarr, Ed Vallier, Mr. Wetchell, Gus Xerogeanes, Bob Barron, Val DeBrer, George Lawry, Ted Jackson, Mr. Fleisher, Mr. Tickler, and Ray Augustus.

In 1916 a four-room, one-story Northbrae Grammar School was built on the San Bruno Toll Road (San Mateo Avenue) on the east side of the Southern Pacific Railroad tracks in the Belle Air Addition. Over the years it was enlarged to accommodate the influx of children from families who chose to live and work in San Bruno and South City industries. During World War II the service personnel needed for the Tanforan Navy base, the Army Air Force at the San Francisco Airport, and San Bruno's EiMac electronic tube production increased the population dramatically.

73

Mrs. Ledwith's fifth-grade class at Northbrae Grammar School in 1941 includes, from left to right, (front row) Theo Sevilla, Alfredo Medrano, Don Provencho, Ray Flanders Jr., Don Barnes, Jack King, Edward Bogart, Jack Gensel, and Ray Verzello; (second row) Joan Vincent, Marilyn Sposito, Lois Payne, June Chesney, Betty Pelee, Helen Baretta, ?, Dawn Anderline, ?, Charlene Schubert (LoReaux), Mary Loplan, and Marilyn Efford; (third row) Virginia Wallace, Jacq Giacomozzi, Ralph DeLaTorre, Mary ?, Sydney Coswell, ?, Kathy Wright, Allen Tuttle, Pat Thompson, Sally Jaime, and Marie Person; (fourth row) Roy Wiedemeyer, Joe Money, Margie Ruiz, Delores Kelly, Frances Pallo, Don Crawford, B.J. Crowley, ? Gifford, and Walter Anderson.

Neatness counts. Short hair was the norm for the boys in this photo at Northbrae in 1950. And all the girls were equally well coiffed. Mrs. Jussila was the teacher.

Mrs. Jussila's graduating class of June 1954 entered Capuchino High School. Capuchino High School was opened in 1950, but with only the freshmen attending. The Class of 1957 became the first full four-year graduating class at Capuchino. At a reunion in 1997 these former students, pictured from left to right, attended: (front row) Sandra Pardini, Marlene Hayes Simpson, Richard McColgan, Karen Chidester, and Teresa Bauer; (back row) Fred Gomes, Charlotte Webb, Stanford Erickson, Maureen Barry, Joan White, and Jerry Norman.

In the 1960s, the explosive growth of the western part of San Bruno required schools in the Portola Highlands and Pacific Heights areas. These locations fell within Pacifica's Laguna Salada Elementary School District jurisdiction, but in 2000, after three or four failed attempts, these schools became a part of the San Bruno Park School District. Shown here in the mid 1960s is the construction of Portola Elementary School.

In 1957, on the former Sneath Jersey Dairy site, land was purchased in the western hills of San Bruno for $900 an acre. In 1964 bonds were passed for construction of the Skyline Junior College campus buildings after Dr. Julio Bortolozzo's massive effort to convince the community that such a facility was needed in the northern section of the San Mateo Junior College District. Originally planned to be built on the eastern part of the land, the campus proper was constructed on the western section. Phillip Garrlington was appointed president of Skyline College which was scheduled to open in 1969. In 1989 30 acres of land on the eastern segment of the campus were put up for sale, with a $19 million bid. However, after much outcry by the citizens, this land offer was withdrawn. In 2003, however, a new bid was accepted, and construction of homes was begun.

Six

PARADES

The citizens of San Bruno held many parades on San Mateo Avenue in the early years. Schmidt's Meat Market (left at 535), Maule Drugs (left at 551), and Ellefsen's Paint Store (to the right at 544) are the only businesses in the middle of the 500 block.

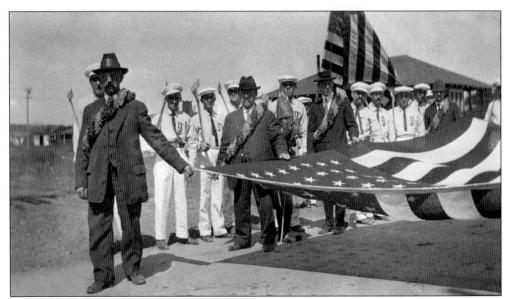

Many of the early residents of San Bruno emigrated from European countries and became American citizens as soon as they could. The California Admission Day Parade became a yearly ritual that allowed them an opportunity to display the American flag and boast of their new citizenship.

The first San Bruno fire truck, the Vim, saw plenty of action at the parades. Here it passes 609 San Mateo Avenue with a full load of volunteer firemen.

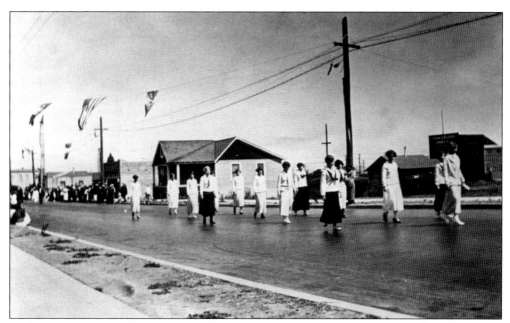

In the September 9, 1924 Admission Day parade a group of women marches along the almost empty 500 block. They have just passed the building at 588 San Mateo Avenue.

As cars became more available in the 1930s they became a routine sight in the parades down San Mateo Avenue. The always popular Carl Hultburg (he later became city clerk) is driving this open-topped car that has just passed the building at 586 and "Hard Hat" Willie Maurer's Insurance business at 588 on San Mateo Avenue.

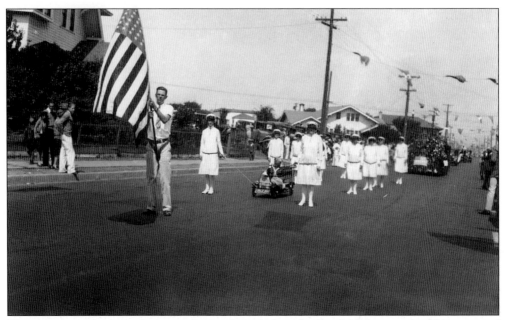

The American flag was always an honored symbol at the head of the parade. This group of nurses passes in front of August Jenevein's house on San Mateo Avenue in 1929. In the background can be seen Dr. Smith's home at the corner of San Mateo and Jenevein Avenues.

Fred Beltramo, dressed as an Indian in front of N.D. Hall on Angus Avenue, gets ready for the parade. With his enthusiasm and originality, he won best costume award several times.

Lining up in front of the car on Masson Avenue before the big parade are a vaquero (Louis Flanders), an unidentified priest, and an Indian (Fred Beltramo). The cavalry is at hand, ready if needed.

Passing the corner of Angus and San Mateo Avenue, these little beauties with their doll buggies are putting on a good show for their parents and people along San Mateo Avenue. In the background can be seen the San Bruno Fire Department building with a tower holding a red-light that would be turned on in a fire emergency.

In front of the Standard Grocery Store (the old P.J. Sullivan Grocery Store), the marchers have passed Kains Avenue. At the northwest corner of Kains can be seen the Osborne Gas Station with the Turf Club next door north.

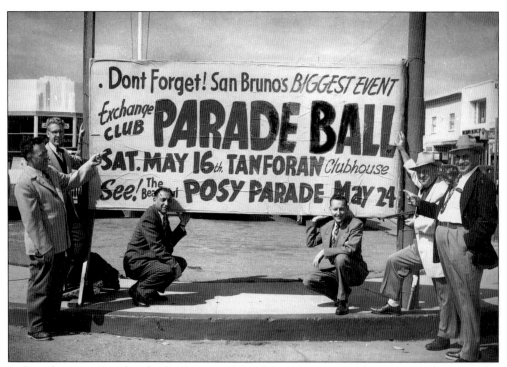

Before the Posy Parade, the Exchange Club of San Bruno would sponsor a dance at the Tanforan Clubhouse to raise money to fund the parade's activities.

In June 1956 this group of little "Uncle Sam's" and their auxiliary march proudly past Artichoke Joe's and a hardware store in the 600 block of San Mateo Avenue. Note the antique carriage on the roof of Artichoke Joe's.

The San Bruno Liquors Store at 542 San Mateo Avenue stands alone with no buildings on either side. In the vacant lot to the left the judges of this 1950 Posy Parade conduct their official duties.

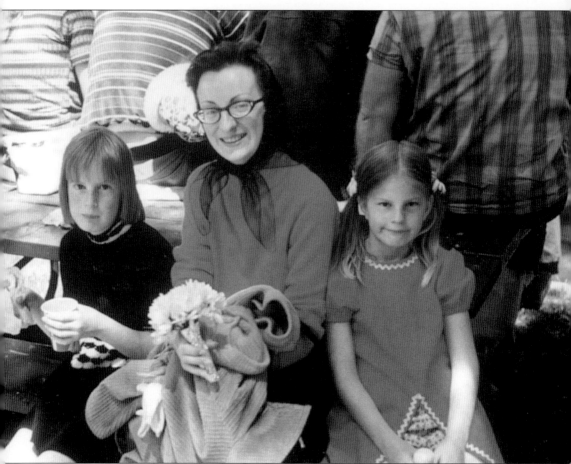

Walking all the way from Masson Avenue, down San Mateo Avenue, crossing El Camino Real, and following Crystal Springs Road to the city park was exhausting for these two "paraders." At the end of the march, however, the Lions Club furnished a cool drink and a hot dog to ease the pain of the moment. The parade had passed by one more time.

Seven

COMMERCE

In the 400 block of San Mateo Avenue, realtor A. Hyde Green built a magnificent two-story building in 1910 to replace the "Town Hall" that burned next to Barney Ward's Bar (Newell's Bar). This hall was bigger and better equipped to handle the large crowds that attended dances and meetings on the second floor. On the first floor, San Bruno's first bank, Bank of San Mateo, began operations, and, in one of the rear rooms, the first silent movies were shown to eager audiences.

Downtown San Bruno in the 1960s was bustling with activity. Green's Hall was being used as a furniture market and, due to the inadequate support of the second floor, the dance craze "the bunny hop" was outlawed by the city council. The slow pace of the traffic allowed diagonal parking of automobiles.

Barney Ward opened his spirits selling business at Sylvan and San Mateo Avenues right after the 1906 Earthquake. In 1925 a second story and living quarters were added to this popular saloon. Dan Newell acquired this business as well as the Albatross Restaurant and Newell's Liquors and developed all three into successful businesses.

Gene Tagliaferi, a semi-pro baseball player, acquired Newell's Bar and it continued to be a popular place in downtown San Bruno. In 1994 Jack Holloway bought the bar. After almost 100 years, Newell's Bar continues to be a landmark in San Bruno at the corner of Sylvan and San Mateo Avenue. Barney Ward would be proud.

William Cole and his wife, Daisy, lived in the rear of their paint business at 466 San Mateo Avenue. Here Mr. Cole is seen delivering paint products to customers in his "Woody" Ford.

From 1928 to 1955 William Cole conducted his paint business out of 466 San Mateo Avenue. Originally built as a music hall and called Harmony Hall, the building housed the *San Bruno Herald* in the 1920s.

When this photo was taken you could pay the admission price of 20¢ to see Century Studio's silent film comedies *A Family Affair* and *Stealing Home* at the Novelty Theater. The Novelty Theater was at the corner of San Mateo Avenue, Taylor Avenue, and El Camino Real. A William S. Hart film is on the bill for the next presentation. Raphael Ricci ran the Novelty Theater in the 1910s and 1920s.

The Novelty Theater was torn down in the late 1920s and construction on a new theater, the El Camino Theater, was started. Talkies had been developed and the new El Camino Theater could show them with the sound. The theater was not completed for almost three years, but when it opened, huge crowds welcomed it enthusiastically. It continued operation as a movie theater until the late 1960s.

Naval personnel stationed at the San Bruno Navy Base at Tanforan helped raise money for the war effort by promoting bond drives.

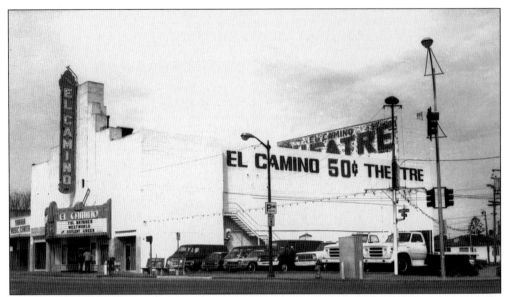

By the 1960s television and other entertainment pursuits resulted in a drastic decrease in movie attendance. The theaters were offering second and third-run pictures that cost only 50¢ admission. Since the El Camino Theater ceased operation in the 1960s, the building has had many other tenants.

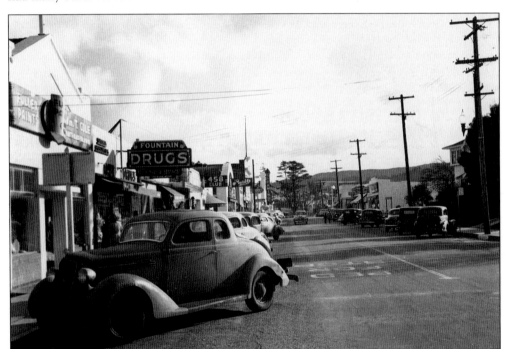

This section of the 400 block of San Mateo Avenue was on the verge of great changes in the mid-1940s. Many of the buildings were old and were to be demolished and rebuilt to accommodate the needs of thousands of new San Brunans moving into the western hills. Most of the cars were of a 1930s vintage, but the return to producing consumer goods after World War II allowed people to update their vehicles. Prosperity after the war completely changed the Peninsula.

The gateway to San Bruno at El Camino and San Mateo Avenue changed dramatically from the early 1900s. Fred Beltramo took this photo in 1964, the city's 50th anniversary of incorporation.

This section of the 400 block became very congested in the 1950s, and diagonal parking would be outlawed by the city to ease the traffic problem. The San Bruno Variety Store (next to the Purity Store) would soon be razed by Joe Welch and a two-story building erected.

Looking north at the intersection of Jenevein and San Mateo Avenue, you see Dr. Smith's house still standing at the corner across from the newly built Bank of America. His home would soon be razed for the construction of a savings and loan institution.

The first full-time physician in San Bruno, Dr. Holmes Smith built a showcase home at the corner of Jenevein and San Mateo Avenue in the 1910s. Next to his home, on Jenevein Avenue, he built his business office where he attended his patients. Across the street from his office was the city park (now the Bank of America parking lot). In 1939 he was shot and killed by a distraught patient who then killed herself.

92

Dr. Smith's brother Harry was a very well-known sportswriter for the *San Francisco Chronicle* newspaper. Harry Smith (the elder) is seen here at the Tanforan Race Track with his nephew, young Harry Smith. Harry followed in his father's footsteps and became a doctor, serving San Brunans until his death in 1984.

In the early 1960s this section of the 400 block is completely occupied and business is good. The sign hanging above the street indicates that more schools need to be built for the burgeoning school population.

This photo by Fred Beltramo clearly shows vacant lots along San Mateo Avenue only a few years before the previous photo was taken. Dr. Smith's gorgeous flower garden, his wife's pride, can be seen to the left. Newell's Bar is on the corner (left) and Maurer's Real Estate and Insurance business is in the newly erected building to the right.

The 500 block (looking north) of San Mateo Avenue in the late 1930s shows Ellefsen Paint Store (on the right at 542), San Bruno Cleaners, (formerly Schmidt's Meat Market at 537), and Josh Maule's first Drug Store (at 551). Many vacant lots are visible and waiting for development.

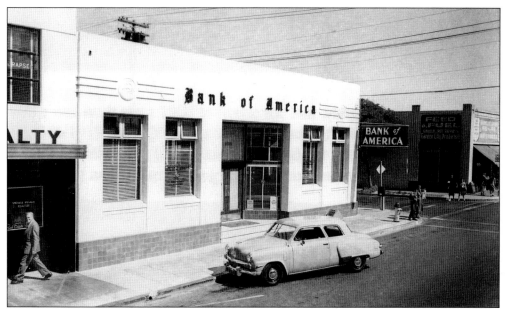

This building at 500 San Mateo Avenue was built *c.* 1923 to house the San Mateo Bank, which had begun in Green's Hall in 1919. In 1925 it became the Bank of Italy and, later, Bank of America. In 1988, after remodeling the building, Lili and her husband, Chun Ho Lee, opened the Hon Lin Restaurant and began serving fine Chinese cuisine.

Joshua Maule opened Maule Drugs in 1922 at 551 San Mateo Avenue. He expanded his business in the 1930s and built a store at 439 San Mateo Avenue and, later, built another at 575. After serving the community of San Bruno for 50 years, the family closed their stores. The advent of large and more efficient chain drug stores in the 1950s forced many small pharmacies out of business. Harry Costa, a prominent businessman of this community, utilized the 551 building for his business in the 1980s and 1990s until he moved into the former Maule Drug Store at 575 San Mateo Avenue to open a new shop, Costa's "Just Things."

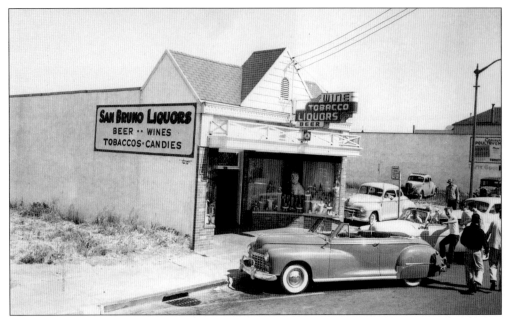

The Ellefsen Paint building on this site was torn down in 1942, and San Bruno Liquors opened with a new structure to serve San Bruno. The Skellinger boys ran the store until Robert retired in 1988. That same year, Suryakant Gandhi bought the business and continues to offer San Bruno residents a variety of liquid refreshments.

Fred Madden's Progressive Grocery Store opened in the 1910s at 583 San Mateo Avenue. Mainly dry goods were sold in the early 1900s as refrigeration was a future invention. Carl Hultberg and the Schmidt Meat Market supplied fresh meat to the community each day. Mr. and Mrs. Madden lived in a room at the back of the store. Here, Mrs. Margaret Oppenshaw Madden poses beside the many items of dry goods and brooms that they offered for sale.

The Grand Leader building at 592–598 San Mateo Avenue was built in 1932 by the Beltramo family and used as a grocery store most of its early existence. In the 1930s the store space at 592 was rented by EiMac (William Eitel and Jack McCullough) and vacuum tubes were assembled in it until the 1940s when the business moved to First Avenue.

In the 1930s William Eitel (left) and Jack McCullough (right) were the founders of EiMac. EiMac, a maker of vacuum tubes for radios and radar, was founded in a small room in San Bruno at 592 San Mateo Avenue. New technology requirements of the Second World War demanded that EiMac produce enormous quantities of these tubes and, when it expanded into facilities on First Avenue, it became San Bruno's largest employer. Thousands were employed to satisfy the war effort and EiMac occupied buildings all over the city in their effort to fulfill their contracts. After the war they began producing tubes for the newly developing television industry. A spectacular fire destroyed the buildings of EiMac between First and Second Avenues in the 1960s.

The DeBenedetti family built this large building on San Mateo Avenue next to a creek (note the wooden sidewalk) in the 1910s for their grocery business. In this photo it is being used as a hardware store and later it was a city recreation hall. In the 1940s it was razed.

The DeBenedetti brothers were successful merchants in Half Moon Bay, and they extended their business interests into San Bruno in the early 1900s. Here, at 609 San Mateo Avenue, a combination business run by Mr. Bacon—a drug store, a hardware store, and a post office—served the public.

In the 1940s noticeable changes have occurred along San Mateo Avenue and to the west of El Camino. Decima Allen School is west of the clump of trees along the El Camino where the new city hall is to be, and the Mills' Addition is getting a new shopping center west of the old city hall (Toyota Motors site). Tanforan Race Track dominates the northern landscape and the "Navy Land" barracks are empty and are waiting to be razed.

Amid much pomp and ceremony, the U.S. Post Office opened in the newly completed brick building at 607 San Mateo Avenue in 1930. Mr. Hughes, the postmaster, gave speeches from a flatbed truck. In the building to the left, 600 San Mateo Avenue, which is to become the San Bruno Drug store, men can be seen inspecting the partially constructed building while waiting for the new postal facility to get a stamp of approval from the public. San Bruno Drug served San Bruno until the 1980s when Jim Cornell moved his San Bruno Vacuum & Sewing Center into the building.

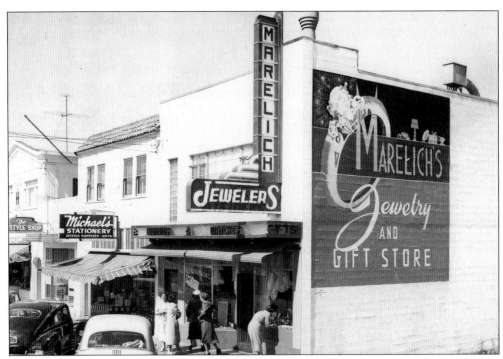

Dan Marelich was a very enterprising individual. For years his shop on Huntington made and sold sheet metal products. In 1939 F. Poirier constructed this building and Dan Marelich began this jewelry shop.

The owners of the San Bruno Herald, Harry and Marjorie Elston, moved into the building next to the San Bruno Volunteer Firemen's Hall at 624 San Mateo Avenue in the 1930s. From 1931 to 1947 this team produced an eagerly anticipated, exciting community newspaper that all of San Bruno read. Local news and stories of individuals in the community reflected the life of the city during the Great Depression and the Second World War.

The Kum Ling Restaurant opened in the 1990s next to an old printing business at 657 San Mateo Avenue: Lynn's Print Shop. The building at 657 had been built in the 1910s and Lynn Kavka moved into the building in 1943.

The Coffman family, father Richard and sons Tim and Kevin, purchased the very successful business of Lynn's Print Shop, Inc., at 657 San Mateo Avenue in 1981. The three continued Lynn Kavka's tradition of fine printing, but moved the shop to 495 San Mateo Avenue in 1988, and the buildings at 657 and 661 were torn down to make way for a parking lot. Kevin is shown here sitting at one of the original printing presses that made its own lead type for printing special orders. The family-owned business was sold to Carlos and Tita Domingo in 1995, and this old linotype machine is now a relic as printing has become high-tech in the age of the computer.

Alvertus LoReaux began his plumbing business in the building that is now Artichoke Joe's on San Mateo Avenue in the early 1900s. His son Milfred, grandson Jack, and great-grandsons John and Ronald continued in the business of plumbing and run the oldest continuous family-run business in San Bruno.

102

Artichoke Joe's began as Joe's Pool Hall at 676 San Mateo Avenue in the early 1920s. Mr. Martin, who had just signed a lease for the property, left one morning with Henry Schmidt to go hunting ducks in the waterways next to the Bay, but never returned. He and the Schmidt boy had drowned when their boat capsized. Joe Sammut I then took over the building and built it into a San Bruno landmark. Joe Sammut also had gambling interests on Geneva Avenue in San Francisco. He and his family—wife, and first son, Joe II—resided on Mills Avenue in San Bruno.

In the 1940s a lunchroom was built to the north of the original pool hall building and in the 1960s the Sammut family acquired the former A. Hyde Green Real Estate building to the south of it.

OUR HAMBURGERS
ARE REALLY
DELUXE

Especially When Washed Down With

GOLDEN GLOW BEER

"Drawn Direct from the Keg"

— ON TAP AT —

JOE'S
PoolParlor

DELICIOUS MEALS and SANDWICHES SERVED

"Where Working Men Meet"

676 SAN MATEO AVENUE **SAN BRUNO, CALIFORNIA**

In the 1960s the Sammut family purchased the A. Hyde Green Real Estate building at 678 San Mateo Avenue and in 1964 it was razed. To the left is the cinder block Frost building and to the right is the original Joe's Pool Parlor wood-sided building. Joe Sammut II's family lived in the white house to the left on Huntington Avenue.

Inside the new addition at 670 San Mateo Avenue, the Sammut family built a unique structure around the card playing tables. The original bars from the first jail on Hensley were purchased and installed around the tables. Patrons had to pass through a steel-barred door to be admitted by a "jail keeper" in order to play. If you lost and couldn't "pay up," you were in jeopardy of being locked up 'in jail' and having the key thrown away.

In the 1990s Marelich's Sheet Metal Company and numerous other businesses were purchased by Artichoke Joe's Enterprises in anticipation of the construction of a larger gambling establishment. Artichoke Joe's then razed the Marelich building. Later the entire section of buildings adjacent to the corner of Angus and Huntington Avenues was razed for additional parking.

In 1990 a steel-beamed structure was built south of the 1964 "jail" addition and the entire inside of Artichoke Joe's was modernized.

San Mateo Avenue as seen looking south from Kains Avenue. The little town of San Bruno was moving on up to city-hood, although in this photo there was more parking than moving.

In 1907 Sebastian and Emilio Della Maggiora erected a building at 737 San Mateo Avenue. They used it for selling wine, groceries, and general goods. Sebastian and his family lived in the back of the store, which was located across from the #40 trolley stop and Southern Pacific depot on busy San Mateo Avenue. It is now used by Dennis Pieraldi as a barbershop.

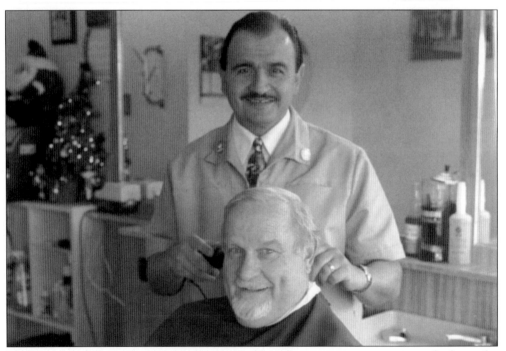

There are two places in every city or town where almost every man visits to find out the latest news or gossip. One of those places is the local hardware store. And the other is the barbershop. In San Bruno, Dennis Pieraldi has cut hair for over 20 years, first at Walt's Barber Shop and later at his own establishment, Dennis's Barber Shop, at the historic Della Maggiora building at 737 San Mateo Avenue.

Eight
SAN BRUNO PEOPLE AND PLACES

Lucy Hook Flanders established her career as a Spanish dancer in San Francisco, but settled down in San Bruno after marrying Louis Flanders. Lucy was a descendent of Jose Antonio Sanchez, the grantee of Rancho Buri Buri. They raised three children: Lucille "Babe," Raymond, and Juanita.

Scheherazade and her sister Susy? Nope, just BABE FLANDERS and FLORA McDONALD with some of the exotic jewelry donated by Eimackers in the "Baubles for Barter" drive just completed. The junk jewelry will go to U. S. soldiers and sailors in the South Seas for trading with the natives.

Lucy Hook Flanders' daughter Babe worked for EiMac during World War II. She is shown here in a publicity photo for a promotion to send jewelry to the South Pacific "natives."

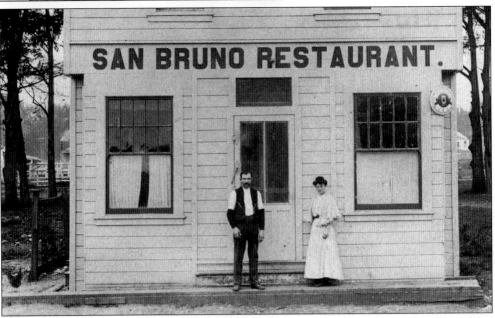

When the 800 block of Huntington Avenue was still a dirt path, Joseph Giboney and his wife, Avelina, started this grocery store and restaurant close to the Southern Pacific train depot and the #40 Trolley Line. Their daughter Gertrude was elected the 50th Anniversary Queen of San Bruno in 1964.

Frank Schaukowitch brought his family to San Bruno in 1918 after he began work installing the sidewalks in the "Heart Area." His wife, Lena, bore eight children, and they built a house at 725 Green to raise them in. Later they built another house at 649 Green, but daughter Margaret, who married Sylvan Selig Sr., continued to live in the house at 725. The children pictured here at 725 Green, from left to right, are (front row) Helen and John; (second row) Victor, Florence, Dorothy, and Margaret; (top row) parents Lena and Frank. John pursued a butcher's career and through the years became well-known in the city. Members of the family owned the San Bruno Scavenger Company for a number of years.

Glorietta Caviglia and her father stand in front of their home on the tree-lined El Camino at the southeast intersection of Euclid in the 1920s. The home later was used as a bar and restaurant called Victor's Inn, run by Victor Zanetti. Later Armond Turiello ran it, calling the restaurant Chip's Serenade. The San Bruno Convalescent Home now occupies the site. Glorietta married Ed McGuire.

Emile Halter moved to San Bruno because he wanted to "live in the country." He bought a number of lots around the hills of 475 Cherry Avenue and built a house and a barn. The barn housed his pigs, chickens, cows, and a number of greyhound dogs that his two sons, Joe and Vic, raised for racing ("coursing") at the Lombardi farm racetrack. Coursing was very popular on the Peninsula, and a professional Greyhound racetrack was built in South San Francisco in the 1930s. Pictured here in this photo, taken in 1924 west of Cherry Avenue, from left to right are Teresa, Mary, Mrs. Halter, Victor, and Joseph with their cows.

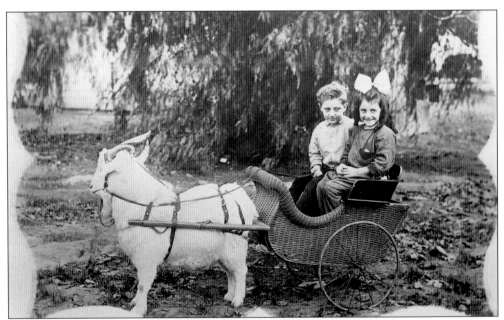

Mildred Cavanaugh Wilson is a direct descendent of the Jose Antonio Sanchez Rancho Buri Buri lineage. Mildred is the great, great-granddaughter of Jose Antonio Sanchez, great-granddaughter of Jose de la Cruz, granddaughter of Maria Cueva, and daughter of Rose who married Andrew Cavanaugh. She was born on Ludeman Lane and, after marrying Albert Wilson, lived in Lomita Park. She is shown in this photo with her brother Gerald.

In 1918 Mary Cebelo's uncle (Matanovich) took this picture of her and her cousins beside the deep, wide creek that flowed through the Uncle Tom's Cabin property, now a Walgreen's drugstore. Marie Matanovich is the tall one in the back and Mary (family lived at 411 Elm) is fourth from the left at age three. In the background is Crystal Springs Road.

One of the most controversial figures in San Bruno was councilman "Hard Hat" Willie Maurer. He stirred up more controversy in the city than most wanted to have stirred up, but he did have a loyal following. His nickname Hard Hat came from the derby he always wore. Despite three recall attempts and numerous lawsuits, he persevered in his duty for 26 years, championing the "little unheard person." He was instrumental in defeating several annexation proposals and helped to defeat several bond issues in the 1940s and 1950s. He lived for many years in a tent that lacked water and sewer, living there ostensibly for medical reasons. He later tore down the tent and built a house to live in on the property at 342 West Angus Avenue

Proceedings Against House of Mystery?

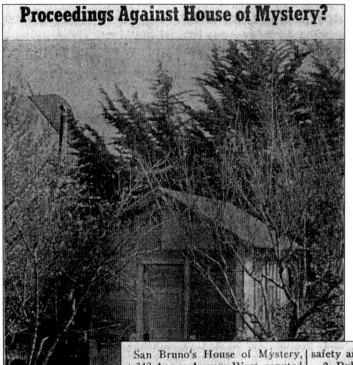

San Bruno's House of Mystery, at 342 Angus Avenue West, reputed to belong to City Councilman William Maurer, may be condemned by city authorities as the result of action taken at Wednesday evening's meeting of the San Bruno city council.

City Building Inspector L. H. Traeger was instructed by the council to start condemnation proceedings following receipt of a report received at Wednesday night's meeting signed by Traeger, fire Chief Joseph Senger and County Health Inspector Mel Schlamm.

The report received by the council, read as follows:

By request of the City Cuoncil of the City of San Bruno, a joint inspection of the tent house and garage located at 342 Angus Avenue West located on lot ½ of 29 and 30, Block J, San Bruno Park First Addition, was made on May 4th, 1948, by Building Inspector L. H. Traeger, Fire Chief Joseph Senger and Mel Schlamm, Inspector of Sanitation, Health and Welfare for the County of San Mateo.

The following violations were noted.

1. General — Uniform Building Code—Sec. 203 relative to health, safety and fire hazard.

2. Rubbish and old cypress trees behind and at side of garage, fire menace. Violation Sec. 15024, 1800 and 1801—Health and Safety Code of California.

3. Illegal foundation—House built on two 4x4 pine poles laying on ground, no air space under building; also termite menace. Violation Uniform Building Code No. 2204-2523. Health and Safety Code No. 15024 - 17455 - 17507 and 17581.

4. No toilet or bathing facilities — Violation Sec. 15024 - 17455 17507 and 17581—Health and Safety Code of California.

5. Rat harbor and fire hazard on grounds, Violation Sec. 17821 — Health and Safety Code of California.

6. Illegal garage—No foundation, dirt floor, roof and sides in bad repair. Violation Sec. 17022 - 17800 and 17801—Health and Safety Code of California.

7. Tent is being used as sleeping quarters at the present time, but it is the opinion of this board of inspectors that it is unfit for human habitation, and the nuisance should be removed.

L. H. Traeger, Building Inspector
J. Senger, Fire Chief
M. Schlamm, Sanitarian.

Matthew Dickson, a contractor and architect, built an imposing two-story Victorian house for his family at the corner of Tucker and Elm Avenues around 1909. Tucker Avenue was later changed to Jenevein Avenue. At the time this was the classiest building in San Bruno. A fire in 1914 damaged the original structure. It was remodeled in 1926 with the addition of a closed front porch and a fireplace in the living room.

Thomas Wiedemann was an adventurer, traveler, civic leader, man-about-town, and editor at times for the *South San Francisco Enterprise*, and for a time he published the *San Bruno Recorder* and also published a number of books. His father, Capt. Conrad Wiedemann, was a world fencing champion and an athletic instructor in San Bruno. His mother, Georgia Luttringer, was widely known for her many social, civic, and political activities. She was co-publisher for the *San Bruno Recorder*. Seen here is Thomas Wiedemann at his "office" on the retail floor of Ellefsen's Paint Store on San Mateo Avenue.

Lomita Park was an independent, unincorporated area between the San Bruno and Millbrae areas since its creation in the early 1900s. It had its own fire department, water system, and sewer hookups. The El Camino Real became the commercial strip of Lomita Park, and many grocery stores, gas stations, cafes, and plant nurseries were built to serve the people in the area. In 1954 Lomita Park was incorporated into San Bruno.

The 1906 earthquake produced thousands of homeless people on the Peninsula. Nearly 5,600 "Earthquake Houses," approximately 20 feet by 15 feet, were built in Golden Gate Park to temporarily shelter those whose homes had been destroyed. Most were razed before the year was out, but a few survived to be transported to other locations. Two such houses were put on railroad cars and moved to 810 San Antonio Avenue in Lomita Park. A high foundation was built to accommodate a small basement, and two houses wer remodeled and joined by a hall. Later, a kitchen, bathroom, and a storage room were built to the rear of the structure. Fred Turner bought these houses from a Mr. Nasso in 1924, and a member of the Turner family occupied the house until the 1990s when it was sold.

Jose de la Cruz Sanchez, son of Jose Antonio Sanchez, lived beside a creek in the Millwood Drive area and directed his ranching operations from his home there. The property was later occupied by a number of families that grew flowers and vegetables. The Capuchino High School campus was developed in 1950 on land that had been used as a golf course. Gypsy Buys offered customers a legendary drinking/dining establishment hidden in the woods at Santa Barbara and Lomita Avenues. This area created its own community of businesses along the El Camino and retained its own identity until it was absorbed into Millbrae.

Giacomo Piedemonte bought five acres of the former Silva Ranch along the El Camino in 1927, across from Tanforan Race Track. The land was put into growing vegetables (and parking cars during races). His wife, Carlotta, and children Robert, Ann, Mary, Joseph, and Louise helped farm and take the produce to the market in San Francisco. To the south 25 acres of land were farmed by the Repetto and Pastorino families. This land is now being developed for apartments, shops, and a hotel.

The Second World War changed the San Bruno landscape forever. The Navy used Tanforan Race Track as Navy personnel barracks while troops were waiting re-assignment to the Pacific fighting units. To the west of Tanforan approximately 180 acres of land were being used as flower and vegetable farms by the Repetto, Pastorino, and Piedemonte families, amongst others. In 1944 the Navy acquired land west of Tanforan for development of barracks for the additional Navy personnel needed in the war. Metal Quonset huts were built for families of Navy personnel where Bayhill Shopping Center is now. At the corner of San Bruno Avenue and El Camino officer barracks were erected next to a large recreational complex approximately where Chili's Restaurant is now. A hospital for the sick and wounded stood where T.G.I. Friday's stands now.

Personality Returns

When Gypsy Buys moved to the Bay Area, she purchased a building in the remote unincorporated hill area near Lomita Park and Santa Rosa Avenues in the 1940s and opened a gambling/eating roadhouse called "Gypsy's." She reportedly had a bed in a second-floor room, acquired while working in Hollywood for Rudolph Valentino. The use of the bed was never explained, but it was rumored that the slot machines and roulette wheels on the second-floor above the restaurant paid off quite handsomely. In 1947 Gypsy's burned to the ground during the night in a spectacular fire.

GYPSY BUYS . . . Many Remember Her

119

In the 1970s the steadily increasing number of San Bruno seniors began asking for a meeting place to conduct their activities, a place to socialize, somewhere to eat a meal, and a place to just relax. The Hatlo Market (the old Purity Store site on San Mateo Avenue) was offered to them, but this proved to be insufficient. Next, a portion of the north wing of the old Edgemont School was remodeled with nutrition facilities and a meeting place, but this also proved inadequate. In 1955, the city council set in motion plans to build a new facility on city property along the creek at 1555 Crystal Springs Road. Construction began, with Peter O'Shea of the Parks and Recreation Department in charge, on the $2.1 million senior center in 1986. Crystal Springs Road had to be widened and modernized, signal lights erected, and a parking lot prepared across the street as well as by the facility.

The new senior center at 1555 Crystal Springs Road was dedicated and opened January 16, 1987. Mayor Bob Marshall and council members Bev Barnard, Ed Simon, Chris Pallas, and Tom Ricci were present at the opening ceremonies, and Wendy Mines was appointed the new director of the facilities.

In the 1950s Mr. Rogers began catering to the commuter by selling wonderfully delicious donuts to eat on the long drive to work. Rolling Pin Donuts developed into one of the most successful businesses in San Bruno and soon expanded into Millbrae, South San Francisco, and Daly City. Eileen, the present manager, makes sure the charities and service organizations in the area are well supplied with goodies whenever a worthy event comes up.

For recreation, the children made up their own activities. Here two girls, Rose Lombardi (left) and Ruth Marceaux (right) are "cruising" San Mateo Avenue on their horses.

Babe Schade's dancing school produced many hopeful Fred Astaires and Ginger Rogers on her wooden platform stage next to her home at 549 Easton. Here are pictured some of the hopefuls at graduation day. From left to right they are (bottom row) Audrey Mawson, Joan Halls, Rosemarie Marinsick, Barbara Jean Skankey, Donna Maher, Sally Perrault, Miss Margaretha Schade, Virginia Parker, Rosemarie Rapsey, Gerian Carlysle, Vera Pahl, Bernadine Rapsey, and Caroline Bleuss; (middle row) Robert Wight, June Natole, Sonia Furtado, June Weir, Jerry Stodick, Rita Lawrence, Martha Jean Pratt, Betty Schubert, Alberta Hanzel, Barbara Eames, Nelda Ledwith, Abbie Fox, Patsy Perrault, and Junior de Lucca; (top row) Bobby Stoeven, Bernice Cidonio, Lois Baker, Peggy Mager, Enid Bishop, La Verene Reese, Charlotte Jamison, Thelma Weldon, Janice Flynn, Alice Garvia, Doris De Vol, Gladys Stoeven, Jackie Downing, Barbara Elston, and Johnnie Schade.

The more adventuresome boys of the area found a great swimming hole in the back hills of D.O. Mills' estate in Millbrae. Here photographer Fred Beltramo records a day in the life of these youths, unfettered and fun.

In 1863 the San Francisco and San Jose Railroad was built along the peninsula through San Bruno. The Southern Pacific Railroad acquired it in 1868. In 1903, the Interurban Trolley #40 was constructed parallel to the railroad bed in San Bruno and began operation from San Francisco to San Mateo. It ceased operation in 1949 and its rails and ties removed. In December 1997, the old rails and ties of the railroad were torn up and construction of the Bay Area Rapid Transportation through San Bruno was begun.

The BART tunnel was under construction along Huntington Avenue in July 2000 after under-grounding of the utilities along Huntington Avenue was completed. The two concrete tunnels that the BART electric trains would run through were poured in a 50-foot-deep excavation that was then filled in with dirt. In June 2003 BART commenced operation from Colma through San Bruno to the airport and Millbrae.

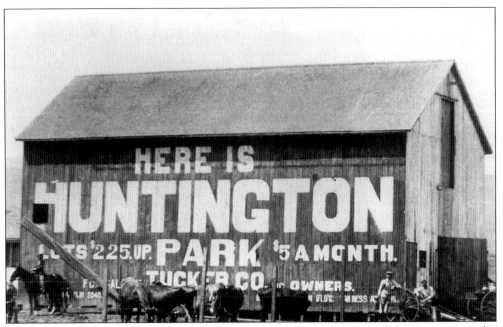

The broadside of a barn near the El Camino advertised Huntington Park lots to anyone who wanted to move to rural San Bruno.

This is an ad for Parkview Terrace #3.

This is an ad for Crestmoor.

In 1957 Perry Liebman began construction on the Pacific Heights Addition in the western hills of San Bruno. Between 1955 and 1965 San Bruno experienced the greatest housing boom in its history, and the city limits grew from two square miles to six square miles. In 1963 the last section of Liebman's 800-house building project was in construction along Longview Drive.

In July of 1963 the Fredricks family moved into a brand new house built by Perry Liebman. This addition contrasted greatly with the first houses built in San Bruno in the early 1900s. Pacific Heights had its sewer, water, curbs, sidewalks, lights, streets, and 50-foot lot requirements in place before any family could move into these three-bedroom, two-car-garage homes. The price of a home was an astronomical $25,000, compared with the $1,500 homes built in the early 1900s.

On November 4, 1769, Gaspar de Portola and his men, after a long, difficult journey, reached the summit of a ridge and saw for the first time the great San Francisco Bay. From this vantage point all of the surrounding area came into view. The journey to today was really just beginning. On May 9, 1984, Portola Discovery Site on Sweeney Ridge was dedicated and preserved for posterity. The site is a part of the Golden Gate National Recreation Area. You too can climb to Sweeney Ridge. Drive to the western end of Sneath Lane, park, and walk the 3.2-mile roundtrip road.